Tutorial:

Bob and Roberta smic
Seramy deter tea

Socail thing? preturmance?

Smoke piring.

cost and holler

Keith ebnever.

fantasic fangi

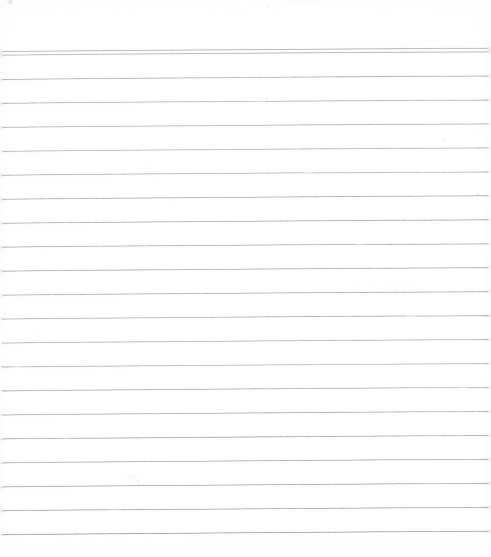

Grizdale arts tea urn

The childrens Book, Book.

Intreasting convosation points
from words on things.

V and A ceramics Trip.

dancil Spoewri

Judy chigago dinner party

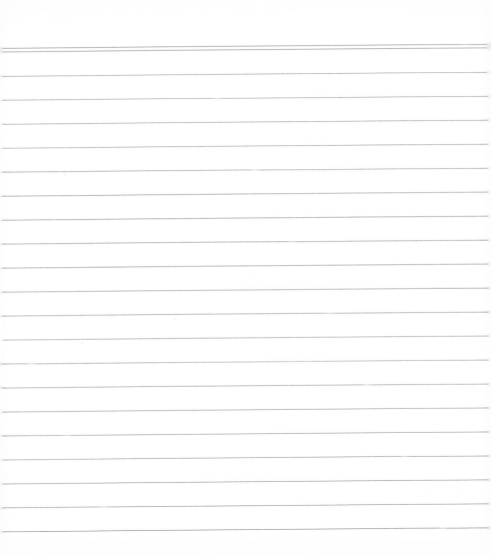

Johnithan miller alice and wonderland.

david throap

william morris gallery

john cage.

Serena Korda

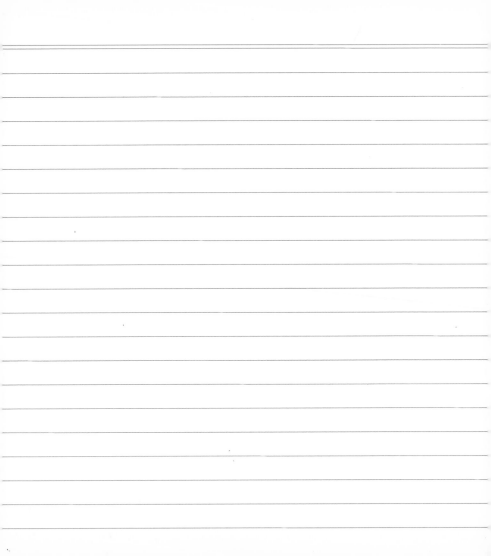

focus more on a mangable set of artists and ideas and bounce them off the question

Stress about word count is normal

refrance and paraphase other peoples work to help boost my word count foot note everything.

Royal college talk:

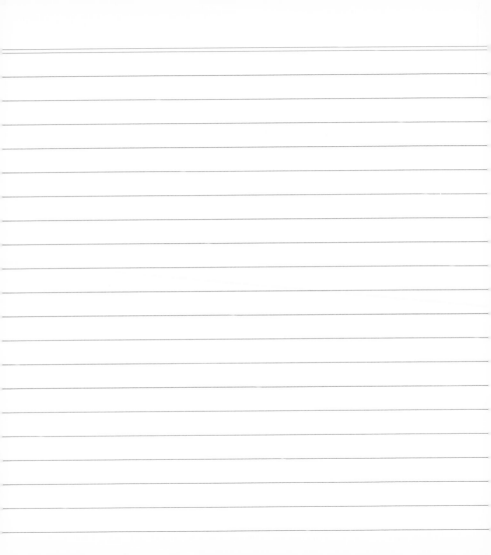